The ANGEL OAK
STORY

The Hoary Giant by Elizabeth O'Neill Verner. A print of this etching of the Angel Oak was presented by Governor Riley in 1986 to the truckers and farmers of the Midwest "in appreciation of help given to our farmers during the great draught." *Courtesy of Ruth Miller.*

The ANGEL OAK STORY

RUTH M. MILLER
WITH LINDA V. LENNON

THE
History
PRESS

Published by The History Press
Charleston, SC
www.historypress.com

First published 2018

Manufactured in the United States

ISBN 9781467141383

Library of Congress Control Number: 2018948026

Notice: The information in this book is true and complete to the best of our knowledge. It is offered without guarantee on the part of the authors or The History Press. The authors and The History Press disclaim all liability in connection with the use of this book.

The Angel Oak
Quercus virginiana

Dimensions in 1981

Circumference of trunk:
25½ feet

Area of shade:
17,000 square feet or nearly one-quarter acre

Largest limb:
11¼ feet in circumference, 89 feet long

CONTENTS

FOREWORD

It's only natural to stand in the shade of the Angel Oak and wonder what stories this tree would tell…if only trees could talk.

It could tell of Native Americans, early explorers and coastal islanders. Of fires, floods and hurricanes. Of celebratory proposals and mournful goodbyes. Of those who sought to profit from it and its surrounds. And it could tell of their defeat.

In 2013, the Lowcountry Land Trust was honored to lead a campaign to secure the purchase of land adjoining the Angel Oak, which was under threat by development. And thanks to thousands of gifts from around the world, the campaign was successful. The Angel Oak Preserve was born.

We know we're only borrowing these special places from our grandchildren's children, and we feel blessed to have had a hand in securing the serenity of a truly sacred place. May it continue to inspire those who've yet to come, just as it has inspired others for hundreds of years.

—Becky Woods, Lowcountry Land Trust

ACKNOWLEDGEMENTS

The author gives special thanks to Becky Woods and the Lowcountry Land Trust.

Thank you to Dr. Richard Porcher for permission to reproduce content from *An Ecological Assessment of the Angel Oak Tract*.

Thank you to Virginia Beach for permission to reproduce "Angel Oak Forever." This article first appeared in the December 2014 newsletter of the Coastal Conservation League.

The author would like to thank The History Press, especially editors Chad Rhoad and Hilary Parrish. They made *The Angel Oak Story* happen.

THE HISTORY OF ANGEL OAK

To all whom these presents shall come, Greeting [1]

T hus wrote Abraham Waight in 1701. The words linger across the centuries, much as the Angel Oak might speak to generations present and future. It is appropriate the story the patriarchal oak would tell is the story of Abraham Waight, for he was the first white man to own the property on which Angel Oak grows. And the story the tree could tell is the story of Carolina. So to all whom these presents shall come, Greeting.

Return to the year 1663. Charles II is restored to the British throne. To reward eight of his important supporters, the king grants them a tremendous piece of property in the New World. The northern boundary is Virginia, the southern boundary at present-day St. Augustine, Florida, and the western boundary the Pacific Ocean. This, the colony of Carolina, is granted to eight proprietors, all experienced in colonial affairs.

The land is theirs to colonize, to govern and to profit from. In essence, the settlement of Carolina was a business operation, and the corporation owners' chief aim was to make money. They understood the way to profit from a colony was to populate the land with industrious, productive settlers.

The proprietors used their knowledge of colonial affairs to compose a legal document that governed Carolina. Complicated and unworkable in many specifics, the early law held two irresistible promises for Carolina's pioneers: land and religious freedom.

The Religious Toleration Act is generally credited to the ablest of the proprietors, the Earl of Shaftsbury, and the influence of his associate the English philosopher John Locke. Carolina offered an island of toleration to Europeans and discontented settlers in other colonies. The Fundamental Orders for Carolina read, "Any seaven or more persons agreeing in any religion shall constitute a church or a profession to wch. they shall give some name to distinguish it from others." This was a unique expression of religious liberalism in an age boiling with religious persecution.

By 1700, Baptists, Huguenots, Jews, Presbyterians, Puritans and Quakers had all come to the Lowcountry.

The lure of the land was equally attractive. A system of "headrights" promised acreage to every immigrant for himself and any others whom he brought to Carolina, including family, indentured servants and slaves.

The proprietors envisioned a feudal system of massive estates supporting a wealthy aristocracy. Their plan for titled nobility with North American *landgraves* and *cassiques* may sound comical today, but the huge tracts of land became the plantation system that determined the whole course of Carolina's history.

It is with the Earl of Shaftsbury and the Quakers that the Angel Oak's story really begins. The Earl, whose given name was Anthony Ashley Cooper, established his personal barony on the south side of the Ashley River. Settlers on his land congregated in the Signory of St. Giles, the area around present-day Middleton Place. Mr. Andrew Percivall served as the Earl's representative in Carolina,

assisting settlers in locating to the colony. By 1675, Shaftsbury had suggested to Mr. Percivall that more lands be opened for settlement south of the Ashley to the Stono and Edisto Rivers. The area, including Johns Island, already belonged to the Earl under English law. However, the Sea Islands were occupied by Native Americans referred to as Cussoe, whom Charles II had never consulted. Wishing to avoid hostilities between the natives and his colonists, Shaftsbury instructed Mr. Percivall to obtain a deed of grant for the territory from the native inhabitants. On March 10, 1675, title was granted to all of "greater and lesser Cussoe," including the "River of Kyewah, the River of Stonoe, and the freshes of the River Edistoh," in consideration of "a valuable parcel of cloth, beads, and other goods and manufactures." This deliberate purchase of land from the Cussoe Indians under peaceful conditions actually preceded William Penn's more famous purchase by seven years.[2]

In September 1675, Jacob Waight, his wife and their son arrived in Charles Towne carrying a letter from Shaftsbury for Mr. Percivall.

The document began, "There come now in my Dogger (the ship *Edisto*) Jacob Waight and two or three other families who are called Quakers. These are but the Harbengers of a greater Number that intend to follow." The Earl's letters of introduction requested that "a whole Colony of 12,000 Acres" should be set aside for the Friends. On the site, Jacob Waight promised his sponsor to build a town of thirty houses and one hundred inhabitants within five years. Each householder, in turn, was promised three score acres for himself and every member of his household.[3] Then follow grants in "Cussoe" to Jacob Waight, and lot number thirteen of the Grand Model for Charles Towne is recorded in his name. Thus, Jacob Waight, an influential Quaker in London, obtained large parcels of land on Johns Island to establish a community of Friends.

Five years later, Jacob's brother Abraham arrived in Charleston indentured to his brother. When his servitude was complete, Abraham, whose words began our story, married Tabitha Nicholls and claimed land in their names. The Waights continued to accumulate land in small tracts and large blocks.[4] A single grant to Abraham on January 11, 1700, contained four hundred acres from the Stono to the head of Wadmalaw River (present-day Church Creek), bounding on other lands owned by Abraham Waight.[5]

The specific property on which Angel Oak stands was part of a small grant to Abraham Waight dated July 25, 1717, for ninety-six acres at the head of Wadmalaw (the marsh at the source of Church Creek).[6] It should be noted that *head* in these old plats refers to the source of the stream, its "head waters."

In 1711, Edward Crisp published a map of Carolina, subtitled a "flourishing province [that] produces wines, silk, cotton, indigo, rice, pitch, tar, drugs and other valuable comodityes." The wines and silks that the French Huguenots hoped to produce never succeeded, but the rice, indigo and naval stores built great fortunes for conscientious landowners. And the Waight brothers soon established themselves as prosperous planters. Abraham, who had arrived fifteen years before as an indentured servant, served as a member of the assembly in 1695.

On Crisp's map, on the northwest side of Johns Island lie two large areas, one labeled Jacob Waightland and the other Waightland (the property of Abraham). A study of plats on file in the Office of the Register of Mesne Conveyance verifies the position of the Waightlands on Crisp's map.

A map by Her. Moll, geographer, in 1715 shows Jacob Waightland across the Stono River on the mainland, and an 1835 map from the *Mills Atlas* labels Abraham Waight's grant as Yates. We must surmise that Mr. Moll made a mistake in placement, and Messes. Vignoles and Ravenel, who surveyed the Mills map, made a mistake in pronunciation.

As prosperous planters, the Waights grew rice on the tidal creeks and rivers of their property. Old plats show the area of marsh just south of Angel Oak was a network of earthen dams that were used to control the flooding in fields of Carolina Gold rice. Fields on higher land bear the label "corn." Indigo likely found its way to the Johns Island fields as well. Indigo, a fine blue dye obtained from the plant, was widely grown on high plantation ground and subsidized by the British government.

Rice-producing plantations in Carolina were not single, vast estates. The most economical size for a rice plantation was about five hundred acres. Planters might own a dozen separate working plantations, each with its own overseer managing forty to fifty slaves. At one time, the plantation on which the Angel Oak stands was a five-thousand-acre tract called The Point, and the neighboring plantation to the west was Back Penn. Both were owned by women in the Waight family.

Jacob Waight and his son passed away and left Jacob's wife, Sarah, as the last member of his family. Her will is interesting, for she leaves livestock to be sold for the benefit of poor Quakers and her land and Negroes to her brother-in-law Abraham, keeping the black families together. Although the Quakers were generally recognized for their opposition to slavery, it appears that in the first generation, the Waights bowed to the realities of life in Carolina and worked their plantations with slave labor. As horrific as the institution of slavery

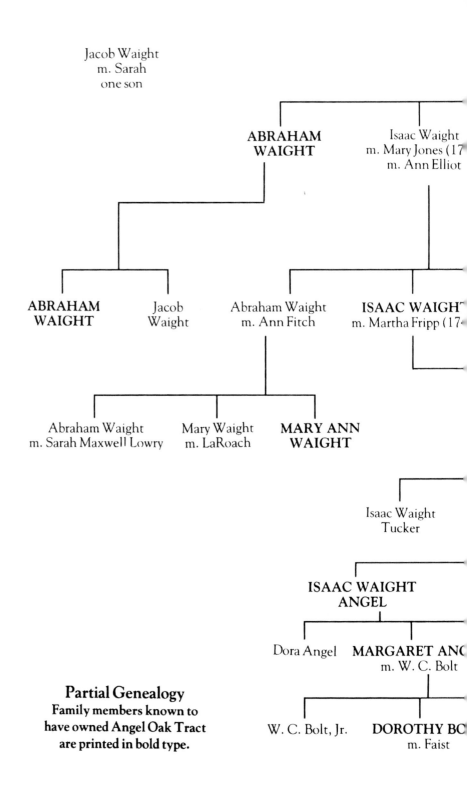

Jacob Waight
m. Sarah
one son

**ABRAHAM
WAIGHT**

Isaac Waight
m. Mary Jones (17
m. Ann Elliot

**ABRAHAM
WAIGHT**

Jacob
Waight

Abraham Waight
m. Ann Fitch

ISAAC WAIGH
m. Martha Fripp (17

Abraham Waight
m. Sarah Maxwell Lowry

Mary Waight
m. LaRoach

**MARY ANN
WAIGHT**

Isaac Waight
Tucker

**ISAAC WAIGHT
ANGEL**

Dora Angel

MARGARET AN
m. W. C. Bolt

W. C. Bolt, Jr.

DOROTHY B
m. Faist

Partial Genealogy
Family members known to
have owned Angel Oak Tract
are printed in bold type.

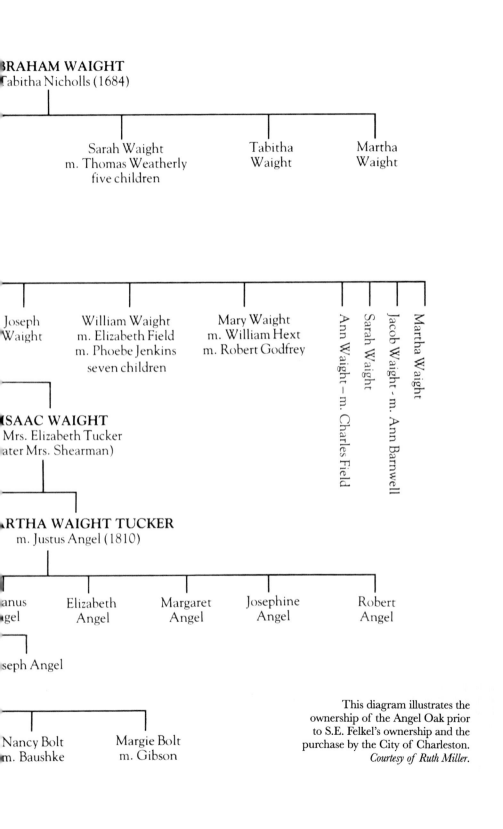

BRAHAM WAIGHT
Tabitha Nicholls (1684)

Sarah Waight
m. Thomas Weatherly
five children

Tabitha
Waight

Martha
Waight

Joseph
Waight

William Waight
m. Elizabeth Field
m. Phoebe Jenkins
seven children

Mary Waight
m. William Hext
m. Robert Godfrey

Ann Waight – m. Charles Field

Sarah Waight

Jacob Waight - m. Ann Barnwell

Martha Waight

ISAAC WAIGHT
Mrs. Elizabeth Tucker
(later Mrs. Shearman)

MARTHA WAIGHT TUCKER
m. Justus Angel (1810)

anus
Angel

Elizabeth
Angel

Margaret
Angel

Josephine
Angel

Robert
Angel

Joseph Angel

Nancy Bolt
m. Baushke

Margie Bolt
m. Gibson

This diagram illustrates the
ownership of the Angel Oak prior
to S.E. Felkel's ownership and the
purchase by the City of Charleston.
Courtesy of Ruth Miller.

was, economics and biology played equal parts in the justification of the use of African slaves, rather than European laborers, whatever a farmer's initial intentions. White residents of Carolina suffered in large numbers from ague, miasma or stranger's fever. All of these names were used for malaria, to which Europeans were highly susceptible.

The Africans, on the other hand, had built up some resistance to malaria over generations of living in tropical climates. Thus, the white planters and others of means migrated during the summers to avoid "miasma." The Legareville settlement was the summer residence of many Johns Island planters. The colonists built a community of houses, complete with a chapel, on the ocean side of Johns Island so the planters could escape both the heat and the malaria-carrying mosquitoes of the Carolina summers.

As already noted, all of Jacob Waight's property passed to his brother Abraham in Sarah Waight's will. Abraham and Tabitha had a large family; six children survived to receive an estate of substance. The Angel Oak's story comes into focus with two sons, Isaac and Abraham Jr. Isaac married Mary Jones of St. Andrews

Parish. Births, baptisms, marriages and wills tell of a prosperous household. The couple owned vast tracts of land on St. Helena Island, as well as Johns Island and in the city of Charleston. However, in every document they are listed as Isaac and Mary Waight of Johns Island, so their principal residence must have been there. Mary had at least seven children before her death. Isaac then married Ann Elliott, the daughter of Thomas Elliott Sr., another of the early Quaker immigrants to establish a well-known family in the Carolinas. The norm for the age saw men surviving several wives, but Ann Elliott reversed the situation. On her marriage to Isaac, she had already outlived two husbands, Jonathan Fitch and Roger Sauders. Ann bore at least two children by her third husband before his death in 1745. Isaac's will reveals much of life among the planter aristocracy. To his wife went all of "her own estate," which she possessed, and money for "looking after the children." To Isaac's son Abraham was left the plantation on which he lived; to son Isaac a plantation on St. Helena; to son Joseph the plantation Cowpenn of 860 acres; to son Jacob the plantation Howard Point of 903 acres; and to son William a plantation on St. Helena.

Isaac Waight's brother Abraham is also part of the story. He inherited the plantation surrounding Angel Oak from his father, Abraham, and continued to reside on Johns Island with his brother Isaac.

In 1734, the story moves to the church of St. Johns, at the entrance to Angel Oak Road, formerly known as Agricultural Hall Road. In the early 1700s, the Church Act was passed by the Assembly of Carolina and approved by the proprietors. The law continued to allow freedom of worship but required taxes for the support of Anglican parishes. Of the ten parishes established, St. Paul's in Colleton County served Johns Island. The parish was so large, however, that by 1734, it was divided, and the three islands of Wadmalaw, Edisto and Johns became St. Johns, Colleton. Local members took a vote to locate the parish church on land belonging to Abraham Waight. The first pew list of the colonial period

shows Isaac Waight held pew number two and Abraham Waight pew number twenty-one. One church document dated September 1777 lists Isaac Waight as a member of the vestry, which orders the church wardens, one of whom is Abraham Waight Jr., to "sell at public venue five negros belonging to the parsonage."

The first sanctuary of St. Johns was destroyed during the Revolutionary War and replaced by a new building in 1817 on the old foundation. The first pew list of the antebellum church contains an important new name: number twenty-seven is labeled Angel.[7] This is the same Angel who is to give Angel Oak its name, for the Waight plantation became the Angel plantation in the year 1810.

The property had been passed through the Waight family until it came to Isaac Waight in the fourth generation. Isaac had two children by Elizabeth Tucker: Isaac and Martha. For some reason, the children were called Isaac and Martha Waight Tucker in their youth, but both dropped the Tucker name later in life. Their father died when the children were young, but not without setting up a complicated system of guardianships and trustees of their inheritance. Of interest to our story is a five-hundred-acre tract that Isaac Waight Sr., of St. Helena Island, released to Charles Snowden, for on this property stands St. Johns Church and the Angel Oak. Snowden held the land in trust because the tract was soon given in a deed of gift to Martha Waight Tucker.[8]

On November 23, 1810, a marriage settlement was recorded that protected the interests of Martha, daughter of the late Isaac Waight, since she was about to enter into marriage with "Justus Angel of Charleston, gentleman."

Justus and Martha Angel lived during the height of plantation life in the antebellum South. Sea-island cotton and corn grew on their high land, rice on the lowlands. Their Johns Island house stood near St. John's Church. A large brick enclosure still stands in the graveyard with a single marble plaque inscribed "Angel." Kinsey Burden's excellent map of Johns Island, dated 1828, gives an idea of plantation life on the Sea Island. The population that year is listed as 120 whites, 2,666 Negroes and 6 free Negroes. Simple division

shows the working of the profitable cotton and rice plantations on Johns Island required 14 slaves for every white inhabitant.[9] The Angels traveled from their plantation house to their home in Charleston and probably spent part of the year in Beaufort and on St. Helena Island. The lifestyle continued until the Civil War, when Johns Island was virtually deserted by its white residents. After the war, the Angel children returned to a land of desolation. Fire raged over much of the island during the war. The church and most of the houses lay in ruin. Freed slaves received forty acres, a mule and anything they could appropriate. The rice plantations died from a lack of willing field workers and competition from less labor-intensive fields in the Southwest.

Cotton continued as king for a while but was devastated in one short year by the arrival of the boll weevil. The Angel children spanned the last generation of the planter aristocracy. Although they inherited large tracts of property, including the one-thousand-acre Angel Plantation on which Angel Oak grows, St. Helena acreage and lots in Charleston, plantation life was replaced by farm life. Isaac Waight Angel, the son of Martha Waight Angel who inherited Angel Oak, grew up in one South and spent most of his adult life in a new South. Born in 1832, Isaac W. Angel attended medical school before the Civil War and served as a doctor in Charleston until 1904. Only at his death did he return permanently to the "resting place in the country" shared by the other Angels.

Isaac Angel's daughter Margaret Elizabeth Angel returned to Johns Island after her marriage to W.C. Bolt following World War I. The Bolt family lived on the Angel plantation in the first half of the twentieth century. Ownership of the tree eventually passed to a daughter, Dorothy Bolt Faist.

Live oaks with some age have branches that touch the ground. These branches never take root. *Courtesy of Chad Rhoad.*

On May 8, 1959, Dorothy Bolt Faist conveyed to Mutual Land and Development Corporation a tract on Johns Island, including the land containing the Angel Oak. This is the point when the Angel Oak ownership passed from the descendants of the original grantee, Abraham Waight, with whom our story began.

There was an agreement in the nature of a lease entered into between the Mutual Land and Development Corporation and the Agricultural Society of South Carolina relating to the care and preservation of the Angel Oak on May 9, 1959. Both the president of the Mutual Land and Development Corporation, W.M. Schram, and the society desired to preserve and save the Angel Oak. The Mutual Land and Development Corporation, for the consideration of one dollar per year, did lease the Angel Oak lot to the society.

The Agricultural Society of South Carolina was founded on August 28, 1785, and chartered on December 19, 1795. The purpose of the society is the encouragement of agriculture in the state and the promotion of arts and sciences contributing to agriculture. Membership is limited to 150 persons.

The society agreed to proceed as soon as feasible clearing the trees and other growth, which they believed interfered with the health, life and maintenance of the Angel Oak.

As soon as the lease was signed, the society employed local tree surgeons who did a tremendous amount of repair work. They removed dead limbs and cleared undergrowth and shrubbery growing through the top of the tree. The tree was fertilized according to analysis. A local horticulturist continued to apply fertilizer when needed and to clean out under the tree. The tree surgeons advised the growth surrounding the tree be left because a tree as old as Angel Oak, having been protected for many years by surrounding growth, would be damaged by high winds or hurricanes if the growth were removed.

The agreement was terminated on May 24, 1963.[10]

The Mutual Land and Development Corporation, owned by W.M. Schram, transferred ownership of the Angel Oak to Shonley Realty Company, owned by S.E. "Speedy" Felkel, on January 31, 1964.

After purchasing the tree, Felkel had the underbrush cleared and had approximately sixty young trees removed from around the perimeter of the oak. These trees were removed in an effort to afford more sunlight to the oak, vital for continued growth. He installed a fence around the entire plot, with an area on the southwest corner left open for public parking and viewing.

E. Harold Keown, author of *Succeed and Grow Rich Through Persuasion*, noted in his book, "S.E. Felkel of Charleston went so far as to purchase and dedicate an ancient oak tree to Dr. Hill. This occurred on Dr. Hill's eighty-first birthday on October 26, 1965. The Angel Oak, a living shrine to timeless philosophy taught and practiced by an ageless philosopher, stands today, a monument to the admiration and love of many who have been helped by Dr. Hill."

The author also related that "Napoleon Hill has been called one of the grandfathers of motivation who has helped build the free enterprise system in America. His original work consisted of twenty years of research on how great men achieved success. Some of those he collaborated with were Andrew Carnegie, Thomas Edison, Henry Ford, and a multitude of others who believed that personal achievement was accomplished through many of the principles described in Napoleon Hill's philosophies. Perhaps his most famous work is *Think and Grow Rich* first published in 1937 which was stimulated by the late Andrew Carnegie."

Shortly after the dedication, vandals destroyed the signs, and the fence and gate were stolen on several occasions. Some carved their initials into the tree.

In the 1960s and '70s, the local Magnolia Garden Club preserved the grounds surrounding the Angel Oak. Members erected signs of direction and information pertaining to the ancient oak. These signs were also stolen by vandals.

In the '60s, the tree was used for picnics during the day and by lovers at night. In the '70s, this site was used by unsavory characters connected with the trade of drugs, and the general public felt unsafe visiting the area during the day or night.

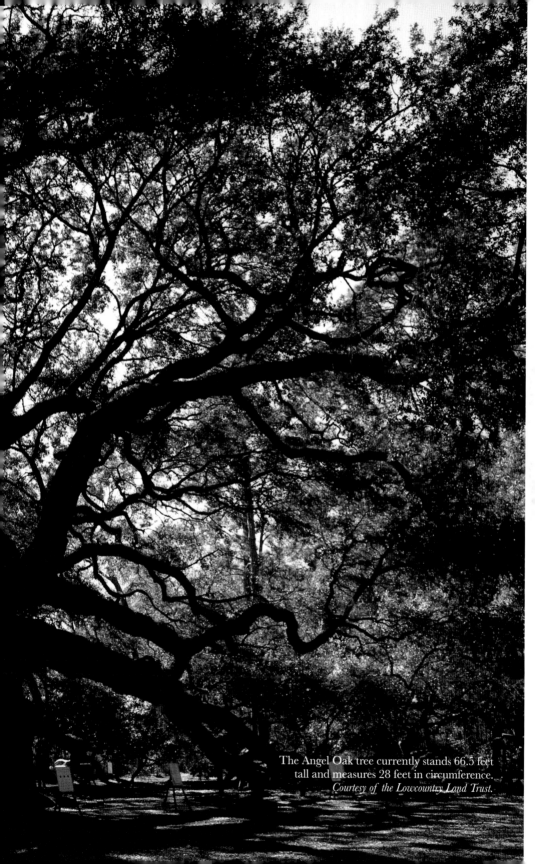

The Angel Oak tree currently stands 66.5 feet tall and measures 28 feet in circumference. *Courtesy of the Lowcountry Land Trust.*

As a result of illegal activities in the mid-'70s, the police dug test holes over the entire tract in an effort to discover bodies that were rumored to be buried there. In the late '70s, the public became so enraged over the vandalism and the unsafe atmosphere surrounding the landmark that S.E. Felkel, at the insistence of the Charleston County Council, took positive steps to protect the tree. He erected an eight-foot chain-link fence and limited public admittance to the tree to times when an attendant was on duty to ensure freedom from vandalism and safety for visitors. He charged a small admission fee to help defray the salary for the attendant and the operational expenses of maintaining the present facilities.

S.E. Felkel is also an engineer and land developer. The following measurements of the oak were obtained by him on March 15, 1981:

Height: 65 feet
Diameter of Spread: 160 feet
Circumference: 24 feet 8 inches
Ground to first limb: 78 inches
Limbs touching the ground: 5
Largest Limb: 11 feet 4 inches around and 89 feet long

He stated, "The age of the Angel Oak was determined after a hurricane in the early part of the twentieth century. A limb on the west side of the tree was blown off during the hurricane. The rings of the severed limb near the trunk were counted. The age was approximated to be 1400 years. This means the Angel Oak was about 1000 years old when Columbus discovered the New World."

South Carolina Wildlife (March–April 1981) included an article on South Carolina trees written by Becky Roberts and Eugene M. McCarthy. They stated, "The 1,450-year-old Angel Oak on Johns Island was already a large tree by the time of the Crusades. According to legend, the twisted limbs of the enormous Angel Oak shaded a familiar meeting site for Indians living on Johns Island."

The Magnolia Garden Club of Louisiana registered the Angel Oak in the Live Oak Society in 1966. Dr. Edwin Lewis

Stephens, first president of the University of Southwestern Louisiana, suggested organization of this unique society in 1934. The purpose of the society is to promote the culture, distribution and appreciation of the live oak. Live oaks in Alabama, Florida, Georgia, Louisiana, Mississippi, Texas, North Carolina and South Carolina are registered. There are more than seven thousand trees registered.

THE LIVE OAK, QUERCUS VIRGINIANA

In 2016, Dr. Joel Gramling and Dr. Richard Porcher Jr. completed a study for the Lowcountry Land Trust entitled *An Ecological Assessment of the Angel Oak Tract*. The fifty-eight-page report includes "Land Use History," "Site Survey and Habitat Discussion," "Plant Species List for the Angel Oak Tract," "Proposed Trails" and such. Of particular interest to our story is the chapter "A Brief Natural History of the Live Oaks," which follows here.

A BRIEF NATURAL HISTORY OF THE LIVE OAKS

The live oak is an iconic tree species for residents and visitors of the South Carolina Lowcountry. The trees are stalwarts on the barrier islands that persist in the presence of sea spray that is carried by the ocean breezes and burns away new leaves with its high salt concentration. The live oaks grow diagonally or laterally as much as they grow vertically, if not more so. In the case of the grandest live oaks, they are much wider than they are long. The roads to historic plantations were lined with live oaks just as select live oaks were allowed to grow in otherwise open fields as shade trees. In the competitive environment of a maritime forest, the live oak has evolved to clamor for a light gap growing crooked and lopsided with a low center of gravity. It is an opportunistic species that will contort to whatever niche is available. In order for that same tree to have the great circumference of a specimen like the Angel Oak, all other competitors would need to be removed. What grows as a meandering asymmetrical tree in its native habitat can produce a tremendous hemispherical crown when cultivated over long periods of time. Thus the grandest of oaks are likely an invention of man, more than a natural wonder. It is this multi-generational partnership between man and plant that is the secret to growing a grand oak.

The Live Oak Society was founded as a way to document the grandest oaks in the United States. The members are the trees themselves and an honorary human member acts as the chairman to assist with maintaining the registry. Humans also nominate the members. If one studies the

registry it provides insight into the relative size and locations of other impressive live oaks across the southeast. The Angel Oak is a member, as is the nearby Middleton Oak. According to the registry the Middleton Oak (31.09 ft. in 2010) has a larger circumference than the Angel Oak (22 ft. when it was first registered over 50 years ago; 25.5–28 ft. today according to online sources), although measurements were not collected as a part of this report. It is interesting to note that these oaks and similarly sized oaks from Mepkin Abbey are examples of live oaks that occur in some of the oldest continuously maintained sites in South Carolina. Unless Native Americans were actively supporting the Angel Oak by removing competitors, it is hard to conceive of how the Angel Oak could be more than 400 years old. The arguments that this is the oldest living tree east of the Mississippi River should be similarly treated with a healthy dose of skepticism. Well-aged cypress and gum trees are much more likely to take that mantle (Rowe 1988). This is not meant to disparage the greatness of the Angel Oak, but rather to provide insight into how humans have actively participated in the cultivation of these magnificent trees. Again the narrative that we read in the landscape of the Angel Oak Tract is one of human interaction with nature.

Another quintessential way that southerners have enjoyed the majesty of the live oak is to plant an oak allée or alley. This is a tree-lined road often use to create a grand entrance leading up to a plantation house. The Angel Plantation house is depicted as having an oak allée leading up to it from Angel Oak Road in 1880 and 1882 plats of the property. We investigated the southeastern portion of the Angel Oak Tract for signs of this feature and found over half a dozen large oaks in this part of the property. In comparison to the Angel Oak, we measured several of these live oaks to be 14–15 feet in circumference. While we can't say for certain when these oaks were established, they appear to line up in such a way that they appear to be remnants of the old settlement described on the 1880 and 1882 plats.

THE LIVE OAK SOCIETY OF THE LOUISIANA GARDEN CLUB FEDERATION, INC.

Constitution and By-Laws

PREAMBLE

Whereas the Live Oak is one of God's Creatures that has been keeping quiet for a long time, just standing there contemplating the situation without having very much to say, but only increasing in size, beauty, strength and firmness, day by day, without getting the attention and appreciation that it merits from its anthropomorphic fellow mortals; and Whereas it has been found that organization and publication are a good means of promoting influence and service in the world; therefore, This Constitution for a universal association of Live Oaks is hereby ordained and established.

ARTICLE I
Name
The name of this association shall be the Live Oak Society.

ARTICLE II
Domicile
Its domicile shall be in New Orleans, Louisiana; the Archives of the Louisiana Garden Club Federation.

ARTICLE III
Sponsors
The Louisiana Garden Club Federation, Inc. will be the sole sponsors of the Live Oak Society.

ARTICLE IV
Object
The purpose of the Live Oak Society shall be to promote the culture, distribution and appreciation of the Live Oak.

ARTICLE V
Membership
The membership of the Society shall consist of designated individual live oak trees, known or suspected to be more than one hundred years old.
Live oaks less than one hundred years old, possessing honorable qualifications, will be eligible to be enlisted in the Junior League.

ARTICLE VI
Officers
Officers of the Society shall be 1. President, 2. Some vice-presidents, 3. A committee of Elders, and 4. A group of illustrious individual speciments.

ARTICLE VII
Representation
For the conduct of the Society's Human-Relations business, a representative (either the owner or some other interested person) shall be designated as attorney for each member.

ARTICLE VIII
Meetings
Meetings shall be held somewhere, semi-occasionally.

ARTICLE IX
Dues
There will be no dues, but each member requests the owners to keep them in good shape and care for them.

ARTICLE X
Amendments
This constitution can be amended at any semi-occasional meeting.

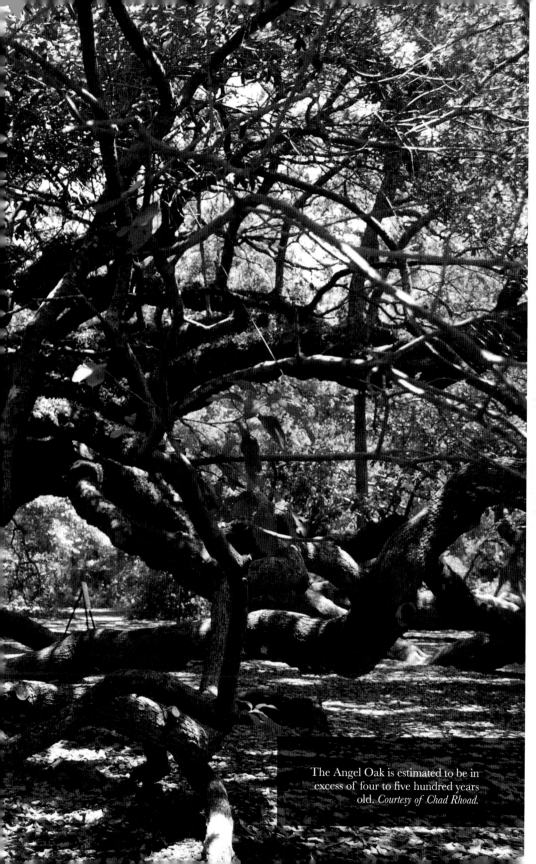

The Angel Oak is estimated to be in excess of four to five hundred years old. *Courtesy of Chad Rhoad.*

BY-LAWS

1. Chairman
The records and correspondence of the Society shall be attended to by the Chairman, appointed by the president of the Louisiana Garden Club Federation, Inc. Certificates mailed to owners or sponsors.

2. Official Organ
The official organ of the Society shall be the Louisiana Garden Club Federation, Inc.

3. Quercometrical Data
Representatives shall be required to obtain and report accurate data as to (1) Circumference of members (measurement of trunk, in feet and inches, four feet above the ground); (2) Approximate height; (3) Diameter of spread; (4) Date of measurements. And this date shall be recorded by the chairman in the archives of the Louisiana Garden Club Federation in a suitable book and preserved for future comparison to show rate of growth of live oaks.

4. The Live Oak in Song and Story
Friends of live oaks everywhere are to be encouraged to contribute not only descriptions, photographs and statistics of measurement, but also poems and stories of historic and literary interest concerning live oaks.

5. The Live Oak in Libraries
Librarians are requested to specialize on live oaks in their collections, and assist in extending live oak appreciation among the people.

6. No Whitewash
Members shall not be whitewashed. Violations of this law shall be punished by expulsion—and the attorneys for such members shall be disbarred from practice.

7. No Advertisements
No member of the Society shall be desecrated with advertisements.

8. No Quercocide
Thou shalt not kill! This law shall apply to members of the Live Oak Society and the Junior League. Destruction of a live oak will not be permitted except by Act of the Legislature.

9. Amendments
These by laws shall not be amended except on a Sunday or holiday or some secular day of the week, or else some night.
Amended—April 1966.

REMINISCENCES

GEORGE AND BILLY HILLS

Billy Hills was born Marshall Whilden Hills on September 18, 1925, in Charleston, the son of George Walter Hills and Janie Taber Lofton Hills. He obtained his BS in horticulture from North Carolina State University. He was president of Three Oaks Landscape Nursery on Angel Oak Road. A past president of the South Carolina Association of Nurserymen and a member of the Agricultural Society of South Carolina, Billy has always maintained a professional, as well as a personal interest in Angel Oak. Billy describes his involvement in the 1988 controversy as "[I] appeared before the Senate Judiciary Committee speaking on behalf of the right to own property without fear of condemnation of such property for use as a public park."

George Washington Hills (1913–1985) owned one thousand acres on Johns Island. He was a member of the Agricultural Society and a friend and neighbor of the Bolts.

George and Billy Hills were raised on Johns Island across from the Angel Plantation. George lived on property that was once a part of the Angel Plantation. He purchased the property in 1936.

George recalled that sometime in the 1920s, Mr. Bolt built a house right where the health center is now located to the left of the Angel Oak. He remembered that Mr. Bolt drove two double-horse wagons from Laurens, South Carolina. Someone—maybe a relative—drove all the way from Laurens with him. The Agricultural Society of Johns Island had a building called Agricultural Hall that it allowed Mr. Bolt to use during his house construction. Margaret Angel Bolt, his wife, came down after he finished the house. He farmed land adjacent to the Hills property because the land on the Angel Oak side was too swampy.

The Hills brothers grew up with Dorothy, Margie, Nancy and Carlisle Bolt and attended high school together.

Billy described the Bolts' house as a one-story frame. An old brick well stood in the yard, possibly from an earlier house. "In the 1930s, the Bolts put up a wooden fence around the Angel Oak. A little booth was constructed to sell tickets. Ten cents admission was charged, and penny postcards were sold. Apparently, traffic wasn't heavy since you sounded your horn and the Bolts came from the house."

George remembered when he was a boy, a portion of the road in front of the Angel Oak passed beneath the limbs of the tree. Most of the traffic then was wagons, carts and buggies. After Mr. and Mrs. Bolt moved to Johns Island, the road was moved. They moved it because the road was on their property and it was affecting the growth of the tree.

Billy noted that various organizations, up until recently, held functions at the Angel Oak. The Scouts, schoolchildren and others had picnics at the tree. The tree became a lover's lane in the 1960s.

The Hillses' father bought his property in 1910 from Warren Wilson. His place stopped right beyond the tenant house on Agricultural Hall Road across from the Angel Oak. Mr. Bolt's land was beyond the tenant house and surrounded the Angel Oak.

Billy recalled, "Our father sold one acre of his land to the Agricultural Society of Johns Island across from the Angel Oak. He sold it with the understanding that if they should ever disband, the

property would revert back to him. They built a hall and used it for their functions. It was in this hall that Mr. Bolt lived when he first came to Johns Island.

"The Agricultural Society of Johns Island was originally Johns Island farmers who met under the Angel Oak. Once a year, they met with their families and had a picnic lunch at the tree."

The perennial Resurrection Fern, *Pleopeltis michauxiana*, and other plants grow on the limbs of the tree. *Courtesy of Chad Rhoad.*

BYAS GLOVER

Byas Glover was born on August 6, 1908. His mother was Lydia Robinson Glover, and his father was Byas Glover. His paternal grandmother is buried in the Angel Graveyard given to the slaves for the burial of their families.

Byas was educated on Johns Island. At sixteen, he went to work for Mr. Bolt and was a loyal employee for nine years. Byas has farmed all his life and continues to reside on Johns Island. He is married to Louise Cohn Glover. They had eight children; six are still living.

Byas revealed his love for the Angel Oak from his youth through adulthood on Johns Island:

The Angel Oak was the most beautiful tree on Johns Island and Wadmalaw Island. I don't see no oak to correspond with that one. It was called Angel Oak because it was given the name after Dr. Angel.

I was raised right by the tree. We used to be out there every day as small chaps. We climb right from the ground and goes up in the top just like squirrels in a tree. We play around there until I became a grown man, and then I go around there and look around and admire it. All the chaps just play there all the time. Just like we work on the farm and when the sun hot, we come to the store or whatever and get your food. Then come back and everybody just sit down there at Angel Oak and eat and have a big time until it is time to go back to work. We played there and took our lunch hours there. The carving and the paint wasn't on the tree when I was a boy. I believe that started about twenty years ago.

I started working for Mr. Bolt when I was sixteen. My parents were born on the Angel Plantation, on the place which you call Hoopstick. It all belonged to the Angels, but that was the name, Hoopstick Island. The Angels had a great number people because Dr. Angel had more property than any place I know on Johns Island. Until 1918, cotton was grown on the plantation. The boll weevil get the cotton. Cabbage, corn and potatoes were grown when Mr. Bolt ran the plantation.

DAVID JONES

S.E. Felkel, one former owner of the Angel Oak, relates folk tales that he heard in 1964:

Shortly after purchasing the Angel Oak, I was discussing the purchase with my friend David Jones of Ladson, South Carolina, who was then in his eighties. David Jones rode over to the tree with me and told me that one of his grandparents had been a slave on the plantation near the Big Oak, as it was called at that time. He remembered a number of stories about life at the oak prior to the Civil War.

To fully appreciate life in that era, you have to understand superstitions and strong religious beliefs of the slaves as well as the plantation owners' families.

One story involves a plantation owner's son, named John, who was talking one day to a slave boy named Sam. It was one of Sam's duties to take the cows from the stable yard each morning to grazing on the land opposite the Big Oak and then return the cows to the stable yard for milking each night about dark. John asked Sam if he was ever afraid when he passed near the Big Oak. Sam said he did not know what afraid was. John said, "You will be afraid tomorrow night."

Courtesy of the Lowcountry Land Trust.

The next night, as Sam came down the road driving the cows, he was whistling. As he approached the Big Oak, he stopped his whistling and began to sing: "Two fraids out tonight, two fraids out tonight. One big fraid, one little fraid, two fraids out tonight." John, sitting on one of the branches of the big oak covered with a sheet, began looking around from under the back of the sheet to see where the other object was. He thought God had sent something to punish him for attempting to scare Sam. At this moment, he jumped or fell from the limb and attempted to run but was either injured or frozen with fear and was unable to move very fast. In the meantime, the object above him, which was the plantation monkey draped in a small sheet, jumped from his perch and began chasing John.

Sam, amused and having no fear, began shouting, "Run faster, big fraid. Run faster, big fraid, or little fraid will catch you."

Another story involves a plantation owner known as George who had some differences with another plantation owner named Henry. Henry's plantation was located about six miles from the Big Oak. George decided late one afternoon to ride his saddle horse to Henry's house and settle their differences with fists. Dueling or settling differences in this manner was common during this period.

When George arrived at Henry's house, Henry was not at home, and he decided to wait until Henry returned. Henry found out that George was waiting on him and sent word that he would not fight and that he was not coming home until George left. George was so infuriated at Henry's refusal to fight that he cut his switch, got in his saddle and started home.

As he passed under the Big Oak with his switch in his hand, a large bird flew down from the Big Oak and started circling him. George thought God sent this bird down to punish him for trying to harm his neighbor. The bird continued to circle until the switch was cut off to George's hand. When George arrived home, people at the plantation found the stub of the switch in his hand, but George was frozen in the saddle from fear. The switch had to be forcefully removed from his hand and George lifted [out of] the saddle.

The next morning, he sent word to his neighbor apologizing and asking for forgiveness.

SEPTIMA CLARK

Septima Poinsette Clark, a native South Carolinian, was born on May 3, 1898. Her parents were Peter Porcher, a former slave, and Victoria Warren Poinsette, a Haitian immigrant.

Mrs. Clark was a schoolteacher from 1916 to 1919, 1926 to 1929 and 1942 to 1970. She was a consultant on education to the Highlander Folk School in Monteagle, Tennessee. She also served as director of workshops, director of education and director of the literary training program to the Highlander Folk School at a later date.

Dr. Martin Luther King Jr., Dr. Ralph Abernathy and the Governing Board of the SCLC (Southern Christian Leadership Conference) chose Septima to become the first director of the Department of Citizenship Education organized by the SCLC.

Published books by Septima include *Echo in My Soul, Champions of Democracy* and *Literacy and Liberation*.

The following was taken from an interview with Septima on November 20, 1980. The tape recording was donated to the South Carolina Historical Society. A digital version is available from that organization.

This page and following: Arborists and maintenance crews use cables to prevent limbs from being damaged by their own weight. *Courtesy of Chad Rhoad.*

I went over there [Johns Island] *in 1916. I finished Avery Normal Institute at the age of eighteen. I went over to Johns Island to teach because black girls couldn't teach in the city of Charleston because segregation was at its height. Over on Johns Island in Charleston County, we were able to teach for six months. Most of the other counties, you only teach two to three months on account of the cotton and the older children having to go into the fields.*

Transportation was really a problem. There were no bridges, and we had to go by boat. It took me nine hours to go from Charleston down to the Promiseland School where I was working and land at that place called Mullet Hall that Limehouse owns today. I would leave here at three o'clock in the afternoon in a little gasoline launch and arrive at twelve o'clock at night. If the tide was not high, then I could not land, and I would have to wait in that little boat until the tide came up the next morning. Then I'd get out there at Mullet Hall and go to that school. I would come home only at the Thanksgiving period because boats only came on Tuesday and Thursday and I would be teaching and I couldn't get a boat. I could have somebody ride me about eighteen miles down the island to what we called Limehouse Bridge. There I could get a train and go into Charleston, and I could go back the same way. I rode on an oxcart to school every day because I lived about a mile and a half from the Promiseland School.

Living there was an extremely hazardous kind of thing. Most of the people living on Johns Island at that time had very uncomfortable houses which were sort of little shacks. Even the white planters papered their walls with funny papers. You could sit in there and read the funny papers when you went to have your claim signed. The Trustees on the island would sign the claim before you could get your money in Charleston.

I had a room up in the attic of a house with a lantern in the ceiling. On Saturday night, which was the great bathing night, I could bathe downstairs in the living room where the chimney was when all the people went to bed. This was the kind of life we had over there.

The people were real funny about religion, and when the teachers went to church and didn't have anything to say, they were considered

not to be Christians. In the summertime, if you sat on the porch with your stockings off, they considered you not a Christian. They declared that the devil was going to get that teacher because you had bare legs sitting out on the porch.

The man I was boarding with had a farm. He had a store, and his wife took care of the people and fed them at dinnertime. Nevertheless, they didn't see that they should buy pots. They cooked the tomato sauce and things right in the can. They had big wash pots that they used to cook the fish. I never worried about the kind of living we had although I had been reared in Charleston with a mother who was a free issue and had been reared in Haiti. She had a lot of cultural ideas from the English. She came over to Johns Island, and it was hard for her to see how I was living.

We had very little water, although we were surrounded by Bohicket Creek. Very few had wells, and they were open-surfaced wells, and when it rained everything went into that well. There was not any safe water. On Saturday when you would have to bathe, you would have to catch the rainwater usually. You would get a tub full of water and bathe yourself, your hair and your clothes all in the same water. There were no outdoor privies, so people just used the bushes.

The Promiseland School was made of logs, and in between the cracks they had clay. There was a big chimney with openings on both sides because it was a two-teacher school. The chimney would heat the people right around the front, and the children to the back, like the teacher, were frozen in the wintertime. My feet really got so frozen that I had chilblains, and there were no doctors on the island at that time. We had to pass this Angel Oak tree to go to Wadmalaw to Dr. Barnwell, who was the only doctor for the five islands nearby. Of course, the people practiced their voodoo and witch doctor things. They told me to heat a potato and put my heel in it, which I did, and I almost lost my heel. I had to go to Charleston to get something done for my feet.

There were 132 black children of school age down there. There were two teachers, and I had from fourth to seventh grades. There were not too many large children until November when the harvest was over.

From the last part of November to the last part of February, we had the big children and the little ones came, too. We would let the little children bring the babies because their parents signed contracts to go into the fields. We had little pallets made of quilts on the floor where these babies slept while I was there. The children brought little buckets with grits and oysters in them for lunch.

"My school was painted black with creosote put all over it. There weren't but three white children down in our section. They had a white teacher for that school, and it was white-washed. They had a bucket with a dipper. We knew this because we went with the white teacher to the Trustee's house to get our claims signed. The Trustee's wife would always give us a jar of pickles or preserves because she knew we were living in a different culture than what we came from. If the man was eating his supper when we went down there, we had to stay out on the porch and wait, regardless of weather, until he finished eating.

Segregation was at its height, but the Angel Oak was not segregated. In the springtime, to have some recreation for the children, we could take a lunch and go to the Angel Oak tree. I did this from 1916 until 1929. We could go in and have our picnics and spend the day. The children played under the tree, and then we would come back in buggies, which were oxcarts.

The island people say that when they tied the oxen to the Angel Oak, it dragged part of the tree over to the other side of the old fence. Now that is part of the tree, too. There are two big limbs over there dragged from the main tree.

The people declared that angels would appear in the form of a ghost at the oak. The killings that

happened around the tree during slavery time were seen by people with a "call." The spirits were around the tree, and it was a live oak and they considered that the angels brought the spirits there.*

That tree is sacred because of the stories black people have heard from their early days. They respect that tree. My schoolchildren never felt they could drop paper around the tree. The very word angel *means that it is sacred to them. They felt that anything like an angel had to be clean, loved and respected. They didn't feel they should do anything to desecrate it. The Angel Oak in 1916 was really as it is today without any carving. People came during the 1950s and 1960s, and everyone wanted to write their names on that tree somewhere.*

My sister-in-law took her little boy and some people to see that tree. The little boy was about three years old, and he fell asleep. When he got awake, he said, "I see a big tree, but I don't see no angels."

*Mrs. Dorothy Bolt Faist, whose family owned the Angel Oak, vigorously objects to Septima Clark's reference to killings. She said that during the time her family owned the tree, no killings took place on their lands.

EVENTS OF THE 1980s

On January 11, 1988, Mayor Joseph Riley of Charleston delivered his inaugural address. The speech would bring the Angel Oak into a controversy that gained national coverage. The *News and Courier* reported on Tuesday, January 12, 1988:

"Next week, Charleston's city government will begin taking steps to acquire land for two public parks on Johns Island," Mayor Joseph P. Riley Jr. said Monday in his inaugural address.

Later, Riley explained how the city plans to establish a five-acre park showcasing the famed Angel Oak tree and a 20-acre recreational park.

"We have given a lot of thought to this," the mayor said about the plan to acquire Angel Oak. "City officials have met with an adjacent property owner, Sea Island Comprehensive Health Care, and proposed to buy or lease three to five acres," he explained. "We got a warm reception and don't think we will have a problem.

"Next to that land, the Angel Oak stands on two acres. The city has advised the owner it is interested in buying that property," Riley said.

"We have gotten an estimate on it, and soon we will get a formal appraisal," he said. "We will offer to pay the fair market value and I feel sure our offer will be accepted."

The tree produces more than 17,200 feet of shade. *Courtesy of Chad Rhoad.*

But, if the owner refuses, the city will invoke "eminent domain," the right of government to take private land for public use, with just compensation going to the owner. "It's not a threat. I feel sure we can get the land. But if the owner refuses, we will proceed with condemnation so the city can acquire it. We are committed to getting it," Riley said.

Riley said Monday night that he could not identify the owner of the Angel Oak because he was unsure in whose name the property was listed.

However, in December of 1986, the property belonged to developer S.E. Felkel. Felkel owed $4.3 million in federal taxes, and the Internal Revenue Service threatened to auction 462 parcels of his property—including Angel Oak. An hour before the sale, Felkel satisfied the IRS and the auction was cancelled.

As it turned out, Speedy Felkel did still own Angel Oak at the time Mayor Riley sought to obtain it. The next day, January 13, 1988, the *Evening Post* read, "The owner of the Angel Oak said today that he won't willingly sell the tree to the city of Charleston because he considers it a 'family heirloom' and doesn't think the city should try to acquire personal property."

On January 21, 1988, the *News and Courier* reported:

Real estate developer S.E. Felkel said he will fight the city if it tries to take the tree, estimated to be more than 1,400 years old, one of the oldest living things east of the Rocky Mountains....

Felkel has erected a solid fence around the tree and charges $1 per person to view it. Felkel said the tree, which is owned by his company, Shonley Realty of Goose Creek, has been in his family for 24 years and that he has promised it to one of his children. Taking it from him would be like taking "the family bible," he said.

"I saw that tree for the first time over 40 years ago and thought it was the most beautiful sight I'd ever seen," he said. "I was later able to buy it and I've developed a special attachment to it."

Felkel stopped short of saying he would sue the city if it condemns the property in eminent domain proceedings. But he said, "I will do anything I can to keep it. I hate to make threats. I hope the public

will support my private property rights. I hope they, too, will resent the taking of a private thing."

He paid $9,000 for the tree and 2.1 acres of land in 1964. County tax records indicate the tree and land are now valued at $46,700 and that total tax on the property in 1987 was $586.

Eminent domain was only one issue to be considered, and the *News and Courier* carried an article dealing with another question:

"Although the famed Angel Oak on Johns Island is not within Charleston city limits, a state law gives the city the right to acquire the tree and surrounding land for a public park," Assistant City Attorney Frances Cantwell said Wednesday.

Ms. Cantwell cited the law when asked how the city can condemn and take property that is not located within the city limits. The law gives municipalities the right to acquire through condemnation any property for public benefit that is located within or outside corporate limits, or in an adjoining county.

It was not long before almost everyone in the Charleston area had an opinion on the "Angel Oak controversy." Letters to the editor appeared in large numbers. Local columnists frequently referred to letters and made comments. This item in Ashley Cooper's column of January 19, 1988, is typical:

Of 3,300 people responding to a Channel 5 TV poll, 97 percent were opposed to the mayor's plan. There is a Johns Island Planning Commission with which the mayor has committed to work closely. This commission had not been consulted at all regarding the proposed acquisition. Beware you property-owners on the Battery! The city is in short supply of boat ramps.
—John S. Sosnowski, Wadmalaw Island

Among the letters that appeared was one from M.W. Hills of Johns Island, which noted, "It appalls me that a municipality can

The location of the Angel Oak. Shaded areas show the city limits. *Courtesy of Ruth Miller.*

confiscate private property for use as a park. Whose property will be next?"

The *Evening Post* of January 21, 1988, reported:

> Council member Mary R. Ader said she has had more calls from citizens on this issue than on any issue since she was elected to council 12 years ago. She said she won't vote to condemn the property and is upset about the mayor's plan to take down the tall fence that surrounds the tree.
>
> "I'm dead set against it," she said Wednesday. "I think this sets a bad precedent and I think the state law should be changed."

On January 23, the *News and Courier* carried a four-column editorial written by Joseph P. Riley Jr., mayor of Charleston. Mayor Riley explained, in detail, his reasoning for the plan:

> The Angel Oak is more than 1,400 years old. It is the Lowcountry's physical heritage personified. It has been admired and enjoyed by inhabitants of this area for all of its existence from the days of the Kiawah Indians to our early settlers and, in modern times, Charleston residents. For all its existence, it was, in essence, in the public realm, available for all to see and enjoy.
>
> A few years ago, it was taken from the public realm by a developer who encircled it with a brutally ugly fence who charges admission. The city now seeks to incorporate it into a gentle and passive park. Why? Does the city have the right to do this? Is it in our community's best interest? These are all very good questions. I will seek to answer them.
>
> We are living in a time of increasing recognition of the importance of preservation and the quality of life in our suburbs. We have been conscious of these issues in our old urban sections and it is very important that we become increasingly conscious of these issues in our suburban and rural areas. The livability of our suburban areas, in part, depends upon the wise and early acquisition of lands for public parks and recreational areas before the area gets too developed. The time to make these acquisitions is before an area is filled with subdivisions, not after.

Our early commitment to the residents of Johns Island was to take steps to acquire land for park and recreational areas as soon as possible.

People have asked, "Should the city be allowed to acquire park lands through eminent domain?" We acquire lands for roads, sewer lines, airports and other public uses through eminent domain. Are parks not just as important?

Of course, they are. What if no one wanted to sell the city land at a fair price for public parks? We would then be a community without parks and playgrounds, and this would be unfortunate. Without eminent domain, the city would not have been able to acquire the land on James Island for the county and city parks, nor would our wonderful Waterfront Park, construction of which begins this weekend, have been possible.

Should the city acquire park land not within its corporate boundaries? First of all, the Angel Oak is now only 300 yards from the current city limits. It is not as if we are going far away from our city to acquire park lands. In essence, it is adjacent to our city right now.

But even if it were farther away, it would be wise for the city to be acquiring the land in recognition of future development while lands in this area are available.

Actually, the city of Charleston has operated facilities considerably outside the city limits for years. The Municipal Golf Course, until very recently, was not in the city limits of Charleston. The Charleston Airport, operated by the city of Charleston for decades, obviously was quite removed from the city limits. Cypress Garden, owned and operated by the city, is some 20 miles away.

Should the city operate part facilities to be used by other residents? Of course, it should.

While the park that will incorporate Angel Oak will be adjacent for nearby residents of the city of Charleston, it will be open to all, like all of our parks.

The Battery is enjoyed by residents not only of the city, but of people from Goose Creek and Summerville. Hampton Park serves not only its neighborhood, cadets and faculty of The Citadel, but also residents of Mount Pleasant and James Island. Our Waterfront Park will be

Left to right: Former president of the SC Urban and Community Forestry Council Ellen Vincent, former Charleston mayor Joe Riley and Assistant Director of Parks Danny Burbage. *From private collection.*

enjoyed not only by Charleston citizens, but by residents of the entire metropolitan area.

I saw a resident of Johns Island the other day and he said, "Don't take our tree away from us." We are trying to do the opposite. We are seeking to give the tree back to the residents. Currently, it is not theirs. It belongs to a developer who has thrown an ugly fence around it and charges $1 to see it.

It is the same mentality that one sees at a county fair where you pay admission to go behind a canvas fence to see something special. I can't believe that any red-blooded Charleston Lowcountry resident can ride down that lovely dirt road that leads to the Angel oak and not feel revulsion and shame when he or she comes upon the ugly fence.

How nice it will be when that same trip will lead to a quiet and gentle park where the fence is removed and the beautiful, sprawling Angel Oak that has belonged to the inhabitants of this area for over 1,400 years is available for everyone to see and enjoy.

We are living in a time where increasingly we must be committed to preserving our heritage and making it available for our citizens to enjoy. The Angel Oak has been ours for centuries—we are seeking to bring it back.

Upon acquiring the property, the city would take immediate steps to enhance the health of the tree and increase its longevity. Our observation is that there has been some deterioration and loss suffered by the tree over the last 10 years. We would limit the amount of foot traffic over the root systems, which activity compacts the soil and causes the root systems to rot. We would be seeking to acquire three to five acres adjacent to the tree that would allow us to give the tree much-needed breathing room. Further, public ownership would ensure that the public would have greater knowledge of precisely what steps are being taken to protect and preserve the tree and have input into the manner of its care.

The question about private ownership is a most important one. Certainly, the right to own and acquire private property is something we all believe in and must preserve. The city's use of eminent domain should never be undertaken lightly, but only after careful thought and as a last resort in the public's overriding interest.

I hope and expect that we will come to mutually agreeable terms with the current owner. But I believe that there are some things that truly belong in the public domain. I believe that for the developer who currently owns it to say that the Angel Oak has become "a family heirloom" over the last 20 years is an unreasonable assertion. It has been a public heirloom for 1,400 years.

It seems to me that this situation is similar to someone finding a way to acquire the only vista to the Grand canyon or Niagara Falls, a vista that had been accessible to all though the years to enjoy the God-given scenic beauty, and fencing it off. A developer comes in, puts a fence around it and says, "I need a dollar before you can go in." The citizens say, "How can you commandeer this view?" And the developer says, "Why just a few years ago, I bought it as our family heirloom."

This is preposterous. Angel Oak and other similar vistas should belong to all of our citizens.

Shouldn't there be some things beyond crass commercialism? Shouldn't there be some places in our beautiful Lowcountry where businesses and developers do not tread? We don't need ugly wooden fences, or ticket-takers, to stand in the way of our enjoying the physical beauty of this tree.

That is why the Nature Conservancy, the Audubon Society and our new Open Land Trust have sought to obtain and preserve unique and priceless areas of our Lowcountry. And that is why the public should acquire Angel Oak, remove the fence, give it breathing room, preserve and protect it, and hand it down to future generations to enjoy.

Joseph P. Riley, Jr.
Mayor, City of Charleston
Jan. 20, 1988

Observers note that the age of the tree continued to increase with the controversy. *South Carolina Wildlife Magazine* stated, "The Angel Oak on Johns Island was already a large tree by the time of the crusades." By January 27, 1988, Mayor Riley responded to the critics of his state of the city address in the *Evening Post* with, "As

interested as we are in the preservation of the lovely oak trees on Highway 61, it would seem that the oldest tree, perhaps, in North America, would have extraordinary interest and support."

On January 28, this poem by Traynor Ferillo appeared in the local newspaper:

Mayor Riley said: "I'll never see
A poem as lovely as that tree.
The Angel Oak was meant for all,
It must be saved by City Hall!"
From City Hall came his decree:
"Annex the land and buy the tree!"
If money fail, we'll make it plain
The oak belongs in our domain!
The Mayor faced a hornet's nest
For planning what he thought was best.
The public screamed and booed his plan
To take by law the tree and land.
And then one night the Mayor dreamed
About his controversial scheme...
Said he: "O mighty oak, I know
For fourteen hundred years or so,
With robins nesting in your hair,
You've held your leafy arms in prayer
While vagrants carved upon your trunk
And litterbugs left trash and junk.
You need some tender, loving care,
And that's a promise from the Mayor!"
"Now cool it, Joe," the tree replied,
"I think you'd better hear my side.
I've had it tough, I do declare,
With birdies messing up my hair
And, yes, I bear some scars from knives,
But, what the heck, I'm still alive!
Go build your park and fishtank, too,

Ain't that enough for you to do?
You want more work? Don't come to me.
You're barking up the wrong oak tree!
I'm happy here behind this fence.
Your plan to save me makes no sense,
So knock it off, I'm in no fix…
This oak and politics don't mix."

On February 11, E.V.H. sent the following ditty to Ashley Cooper for inclusion in his column, asking if it were still timely:

Re: The Angel Oak
A park, a park, a waterfront park!
Have you seen the plans for the Waterfront Park?
A hotel, offices and shops!
No, we have not been kept in the dark,
But as our mayor so blithely hops
From a taxpayer's dream of an open park,
He points with skill the other way.
And says, no joke,
That he will take the Angel Oak.
And that's all anyone heard him say.

National media picked up the story. *Life* magazine of April 1988 described the "Talk of Charleston" in its Snapshots column. The *Washington Post* was among out-of-town newspapers that picked up the story from press services, and Speedy Felkel appeared with his tree on a national television show.

The controversy led to an attempt to change the state law that allowed Mayor Riley to exercise eminent domain. Spearheading the issue was Senator Sherry Martschink, Republican–Charleston. She offered legislation in the state senate that read, according to the *News and Courier* of February 4, 1988, "A municipality may not condemn land outside its corporate limits for purposes of establishing a park, playground or recreational facility, and the establishment of a

park, playground or recreational facility by a municipality outside its corporate limits is not considered to be a public purpose of the municipality for which the power of eminent domain may be used."

Senator Martschink was not successful. On Thursday, May 19, 1988, the *News and Courier* announced:

> *On Wednesday, the Senate Judiciary Committee, by a vote of 5 to 4, agreed to carry over until the next session three separate bills that would have stopped the city from claiming the state's oak and surrounding land on Johns Island.*
>
> *The trio of bills would have prohibited a municipality from using its powers of eminent domain, or condemnation, outside its corporate limits for the purpose of providing parks and recreation-related areas.*
>
> *By carrying the bills over until the next year, the committee is, in effect, killing the measures.*

Although the mayor could still take the tree legally, in August he bowed to public pressure and announced the Angel Oak Park plan was on hold.

EVENTS OF THE 1990s

On September 24, 1991, the *News and Courier* reported:

> *Last November, the Internal Revenue Service announced it would sell the tree at public auction if Felkel didn't pay delinquent tax liens by Dec. 4. He failed to pay, and the city submitted a high bid of $127,900 at the tax auction, beating out the Florida entrepreneur.*
>
> *The IRS gave the city outright ownership when Felkel failed to remit his back taxes by June. City Council subsequently allocated another $25,000 to satisfy a mortgage held by the Stoney family, which had sold the tree to Felkel in 1964.*

On September 23, 1991, Mayor Riley dedicated Angel Oak Park. This event guaranteed that the tree would be protected and honored. The day marked the end of the controversy and the city's formal opening of Angel Oak Park.

EVENTS OF THE TWENTY-FIRST CENTURY

The land surrounding Angel Oak was threatened by a major development in the twenty-first century. Virginia Beach wrote a clear and concise record of the events: the threat to the ancient tree, the establishment of the nonprofit Save the Angel Oak, the cooperation between individuals and organizations and the final successful results produced by extensive civic participation.

ANGEL OAK FOREVER

The venerable Angel Oak stands guarded by a small city park and a modest chain link fence—its only defense against the steamroll of a speculative real estate market. Today, this centuries-old, sea island icon will be forever protected, thanks to the vision and passion of dedicated individuals, the power of the law, and a unified and inspired community.

In 2005, a development was proposed on a tract of land at the intersection of Maybank Highway and Bohicket Road, adjacent to the Angel Oak. Initially designed for dense residential development and big box retail, the development as planned was roughly equivalent to the density of downtown Charleston, fifteen times greater than what is allowed for the most concentrated areas of John's Island. Simply put, it was completely inappropriate.

Several of the tree's limbs rest on telephone poles to ease stress on the tree during inclement weather. *Courtesy of Chad Rhoad.*

MORE THAN A TREE

Dubbed Angel Oak Village, the development was problematic not only for the Angel Oak tree, but also for the surrounding ecology and character of John's Island. The majority of onsite trees were slated for removal and the land was to be almost completely covered with pavement and apartment buildings. To prepare the site for construction, the developer planned to fill wetlands connected to Church Creek. All of these activities would lead to substantial increases in nonpoint source runoff and do irreparable harm to the site's wetlands and nearby creeks.

Classified as shellfish harvesting waters, Church Creek is protected by law for shellfish harvesting, recreation, crabbing and fishing. But Church Creek is also listed by the Department of Health as an impaired waterway because current levels of stormwater runoff are contributing to high fecal coliform bacteria and low dissolved oxygen levels. Furthermore, Church Creek connects to Bohicket Creek and other smaller tidal creeks, waters that are favored by local fishermen and relied upon by the surrounding community.

The Coastal Conservation League expressed serious concerns about such a dense development immediately adjacent to the Angel Oak, Church Creek and the Charleston County Urban Growth Boundary. In 2008, the City of Charleston approved the development, which was revised to eliminate the big box component, add a six-acre conservation zone, reduce some wetland fill and slightly increase the buffer around Angel Oak. Despite these changes, the development was still incompatible with the unique natural and cultural history of John's Island.

TIME TO ACT

About this time, John's Island residents Samantha Siegel and Lorna Hattler became alarmed at the prospect of the ancient tree they had come to love being engulfed by an apartment complex. They started a petition drive, garnering more than 12,000 signatures, and founded a nonprofit called Save the Angel Oak. In 2009, they teamed up with the Conservation League to engage forest ecologist Dr. Jean Everett and wetland delineation expert Bridget Lussier to review the site and the impacts of the projected development. The two scientists submitted their

reports to the Army Corps of Engineers. At the same time, the League began floating the idea of a conservation purchase and commissioned an appraisal of the property.

The following year, the Corps ruled that the wetlands fell under federal jurisdiction, which mandated that the developer secure a permit to fill them. Then the League formally approached the developer about selling the Phase II portion of his land as green space, contingent on the community raising the money to purchase the site. Though the developer ignored the offer, the League continued to promote the concept of the Phase II tract becoming an expanded public park area—to protect the historic Angel Oak and its surrounding landscape, teach visitors about Gullah Geechee history and culture, and highlight sea island contributions to the nation's civil rights movement.

In 2011, the developer received permits approving his stormwater pollution prevention plan and his request to fill wetlands on the Phase I tract. The League and Save the Angel Oak, represented by the South Carolina Environmental Law Project, submitted comments objecting to the permit and entered in litigation to appeal its issuance. During the course of the appeal of the permit, the developer foreclosed on the property. His lender, the Coastal Federal Credit Union, gained control of what was now a 36-acre property comprising Phase I and Phase II. (The City of Charleston had previously purchased the developer's six-acre conservation zone to add to the two-acre city park surrounding the tree.)

SAFE AT LAST

After extensive negotiations with the Coastal Federal Credit Union, the Conservation League agreed to drop their appeal of the Phase I permits in exchange for a new appraisal of the Phase II property and an option for the Lowcountry Open Land Trust to buy it. A settlement was finalized in early 2013, which succeeded in adding more acreage in the option to purchase.

The Land Trust immediately went to work to raise the $3.6 million necessary to purchase the Phase II tract. They secured two 90-day options to allow enough time for a community fundraising campaign.

Members and volunteers with the Lowcountry Land Trust help keep the area around Angel Oak clean.

Next they developed a multi-faceted park and preservation plan for the property, re-naming it Angel Oak Preserve and enlisting the Charleston County Parks and Recreation Commission as a partner. On July 16th, the Land Trust was awarded a $2.4 million grant from the Charleston County Greenbelt Fund for the purchase of the property. That left $1.2 million to be raised over the remainder of the summer and fall.

Thousands of sea islanders, Charlestonians and friends from around the world responded. Local municipalities, businesses and corporations made significant contributions. Community nonprofits and foundations also donated. Combined gifts flowed in at a rate of $8,000 to $10,000 a day. By the end of October, $750,000 had been collected.

Then on November 6th, the S.C. Conservation Bank approved a grant of $890,000 toward the project, lifting the Angel Oak campaign over and above its goal. More than $4 million was raised, enough money to cover the purchase of Phase II, the design of the preserve, and possible acquisition of more acreage. The dream of an Angel Oak Preserve would be realized.

Opposite, top: The park is operated by the City of Charleston and is open to the public admission-free. *Courtesy of Chad Rhoad.*

Opposite, bottom: Thousands of visitors pass through the visitors' center each year. *Courtesy of Chad Rhoad.*

NOTES

1. Register Mesne Conveyance (RMC), McCrady Plats, #4570.
2. Henry A.M. Smith, "Baronies of South Carolina," *South Carolina Historical and Genealogical Magazine* 11, no. 2 (April 1910): 75–91.
3. South Carolina Historical Society Collection, Shaftsbury Papers, vol. 5, 464, 465.
4. South Carolina Historical Society, Waight, compiled by M.A. Read, September 1915.
5. RMC, McCrady Plats, #4570.
6. RMC, McCrady Plats, #2536.
7. Sophia Seabrook Jenkins and Reverend Robert N. MacCullum, *Commemorative History of St. Johns Parish, 1734–1934* (Charleston, SC: Walker, Evans and Cogswell, 1934).
8. RMC, vol. T-6, 76.
9. Library Society, Kinsey Burden Map, 1828, original.
10. Agricultural Society of South Carolina files.

INDEX

ABOUT THE AUTHORS

Linda V. Lennon is author of *Charleston's Historical Churches and Chapels of Ease*.

Ruth M. Miller is author/illustrator of *Charleston Charlie*. She is the coauthor of *Charleston's Old Exchange Building: A Witness to American History*, *Touring the Tombstones* (a series of guides to Charleston's eighteenth-century graveyards) and *Slavery to Civil Rights: A Walking Tour of African-American Charleston*.

Visit us at
www.historypress.com